This book is full of beautiful lettering, detailed instructions and practical tips.

This book now belongs to you!

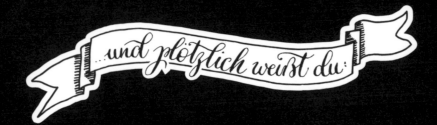

...und plötzlich weißt du:

ES IST **Zeit,** ETWAS **Neues** ZU BEGINNEN, UND DEM **Zauber** DES **Anfangs** ZU VERTRAUEN.

MEISTER ECKHART

... and all of a sudden you know

IT IS **time** TO START SOMETHING **new** AND TO ENJOY THE **joy** OF A **new beginning**

LIST OF CONTENTS

VIEL SPASS!

HAVE FUN!

Das Geheimnis des Erfolgs ist anzufangen.

MARK TWAIN

The secret of getting ahead is getting started

"You do not need expensive equipment to successfully produce beautiful handwriting. A bit of practice, a little perseverance, concentration, a lot of inspiration and most of all pleasure are the ingredients necessary for small, hand-crafted works of art."

❦ PREFACE ❦

You see beautifully drawn letters everywhere nowadays: in advertisements, on house facades, when you are out shopping and on the internet - they are omnipresent. Hand lettering is a trend that has become very popular in DIY culture. Handmade items and handicrafts are generally more appreciated again, because they embody charm and character. Using hand-drawn letters you can give a shape to words and emphasise their message.

Übung macht den Meister ...
Practice makes perfect

... This also applies to hand lettering, so it is definitely worth persevering. When I first started, I would never have thought that I would publish my own book on this subject one day - but it is perfect proof of this point! Just as the quote from Mark Twain suggests, you can begin to see success after a short period of time. But be careful: there is a danger of becoming addicted! Once you start, you can quickly get hooked on hand lettering! What started for me as an idea and then became a hobby has now developed into a professional passion. It is a passion that still requires a lot of practice, as it has always done, but I also find it wonderfully relaxing.

There are many reasons to take up hand lettering – but for me, one reason in particular is paramount:

TO RELAX AND UNWIND

It can be very restful and relaxing to work with pens, brushes and paper - away from the computer and the hustle, bustle and stress of everyday life. Simply switch off your telephone and immerse yourself in the world of lettering. Perhaps you listen to good music at the same time, or, like me, you simply enjoy the peace and quiet around you. Take a private break to enjoy your lettering and unleash your creativity.

You do not need expensive equipment or any particular prior knowledge to get started. It is not important if your handwriting is not very beautiful; that is not what hand lettering is primarily about! Just let this book inspire you, try things out for yourself, find your own style and, most importantly, have fun and enjoy it. Maybe you will feel like doing more! The best thing is that you can start simply - anywhere and anytime.

I would like to give you two things to take with you on your lettering journey:

1. No one is born a master - it sounds trivial, but it is true ... even I have to practise every day to make further progress.
2. Hand lettering has nothing to do with perfectionism - if you like it, it is perfect, just as it is.

So grab your pens, have fun and enjoy hours of relaxation while you are lettering, writing and designing letters.

Katja

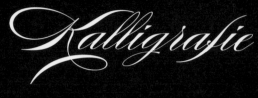

Calligraphy

In **calligraphy**, the art of producing "beautiful handwriting", the most important thing is to achieve the perfect aesthetic form. You work with a pen and nib and ink or Indian ink. The artistic calligraphy effect is produced by making thin upward strokes and thick downward strokes.

Modern calligraphy does not adhere strictly to the rules of traditional dip pen calligraphy (see above). It is more individual and offers more freedom of design to give the writing a modern touch. Here too, thin upward strokes and thick downward strokes produce the calligraphy effect, but do not need to be executed in such an exact way as in the case of classical calligraphy.

Modern calligraphy

Typography

The term "**typography**" refers to the arrangement of finished texts. In the past, printers laid out lead or wooden letters to do this. This technique is still used in classic book printing or letterpress printing, but nowadays texts are more frequently produced on the computer.

In the case of **hand lettering**, the letters are drawn rather than written. Individual styles of writing are created using a range of different implements. Each individual letter, each word or stroke is given an exceptional appearance with a unique character of its own.

For **brush lettering** a brush or brush pen is used and you work with Indian ink or watercolour paints. Depending on whether a small or large, coarse brush/brush pen is used, different styles of writing are created. As in the case of calligraphy, thin upstrokes and thick downstrokes are key features of brush lettering.

Brush Lettering

Faux Calligraphy

Faux calligraphy (false calligraphy) is really a practice technique for calligraphy. A word is written using a pencil or fineliner and a second stroke reinforces all the downstrokes. Then the double stroke can be left as a design feature or the two strokes can be combined, once again creating the "calligraphy effect".

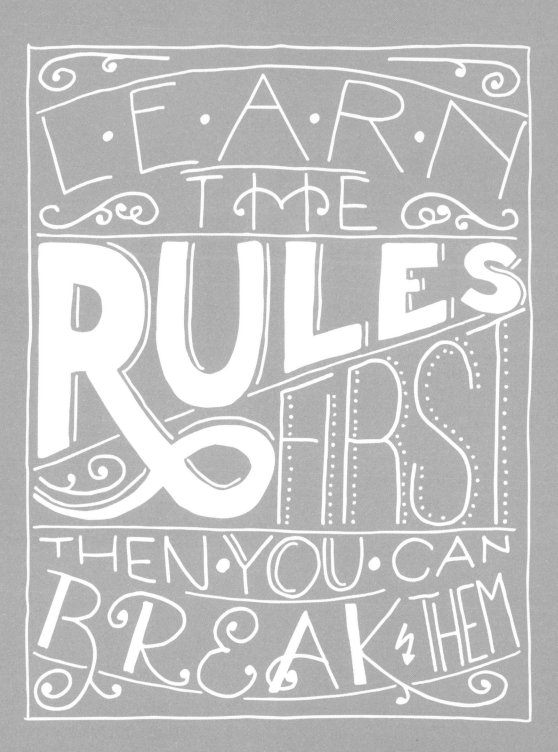

In contrast to typography, hand lettering is not governed by strict rules, which means that no previous knowledge is needed. A brief look at the basics of typography cannot do any harm to start with, however, and it often makes the small but subtle difference to the end result if you know what you need to look out for.

THE STRUCTURE OF LETTERS

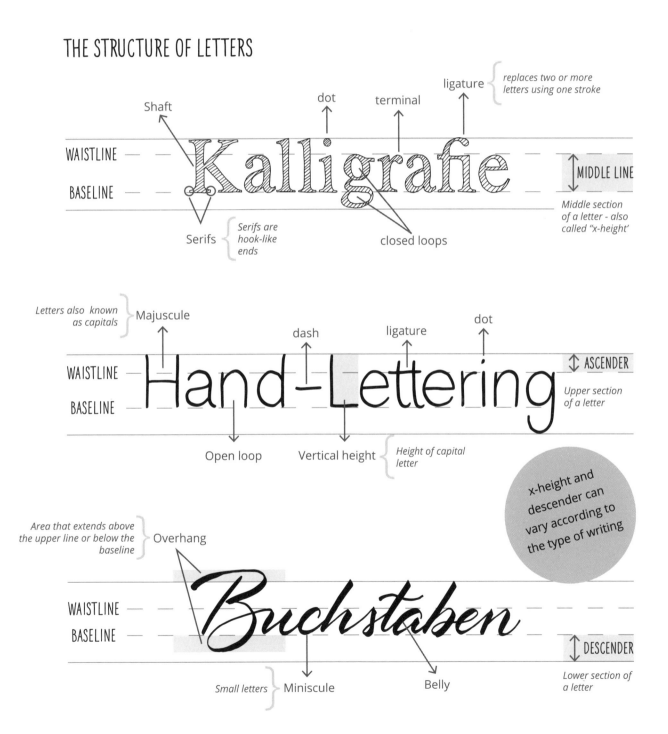

ligature { replaces two or more letters using one stroke

Shaft

dot

terminal

WAISTLINE

BASELINE

Kalligrafie

MIDDLE LINE

Middle section of a letter - also called "x-height"

Serifs { Serifs are hook-like ends

closed loops

Letters also known as capitals { Majuscule

dash

ligature

dot

WAISTLINE

BASELINE

Hand-Lettering

ASCENDER

Upper section of a letter

Open loop

Vertical height { Height of capital letter

x-height and descender can vary according to the type of writing

Area that extends above the upper line or below the baseline { Overhang

WAISTLINE

BASELINE

Buchstaben

DESCENDER

Lower section of a letter

Small letters { Miniscule

Belly

9

❧ THE BASICS ❧

Apart from the structure of the letters, there are specialist terms that are also used in hand lettering. These are terms that characterise and differentiate the types of writing and letters. Here is a short collection of various examples:

OTHER TYPOGRAPHICAL TERMS

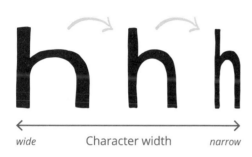

wide Character width *narrow*

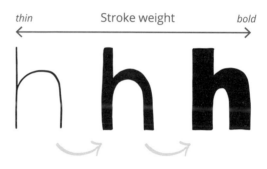

thin Stroke weight *bold*

Writing styles (e.g. stroke weight, character width, italic versions, etc.) can look very different.

e *e*

Cursive (italic)

First of all, in serif fonts there is a true cursive style. In this case, the cursive letter is drawn differently. Explanation: the left-hand "e" is in normal font, the right-hand "e" is in cursive style.

m *m*

Slanting (oblique)

In contrast, in the case of sans serif fonts, there is usually a so-called slanting style. In this case, the normal letter is simply placed in an oblique position.

Outline

Inline

Shadow

3D-effect (shadowed)

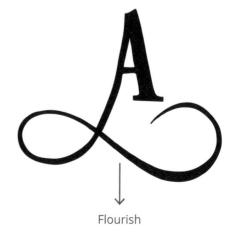

Flourish

LIGATURES

A ligature connects two or more characters in one stroke, avoiding any unsightly overlaps.

Example of a ligature

fi fi ffi ffi

&

One of the most well-known ligatures is the ampersand (&), which comes from the French word "et" meaning "and". It is a combination of the two letters "e" and "t" and is used in a wide variety of shapes.

&

GLYPHS

are the graphic representation of a letter, symbol, special character or ligature within a script.

butterfly

NUMBERS

In the case of numbers, a distinction is made between medieval numerals and lining numerals. Lining numerals are the height of capital letters and are aligned on the baseline. They are not as easy to read as medieval numerals, which have descenders and are therefore better integrated into the overall body of the text.

1 2 3 4 5 6 7 8 9 0

1 2 3 4 5 6 7 8 9 0

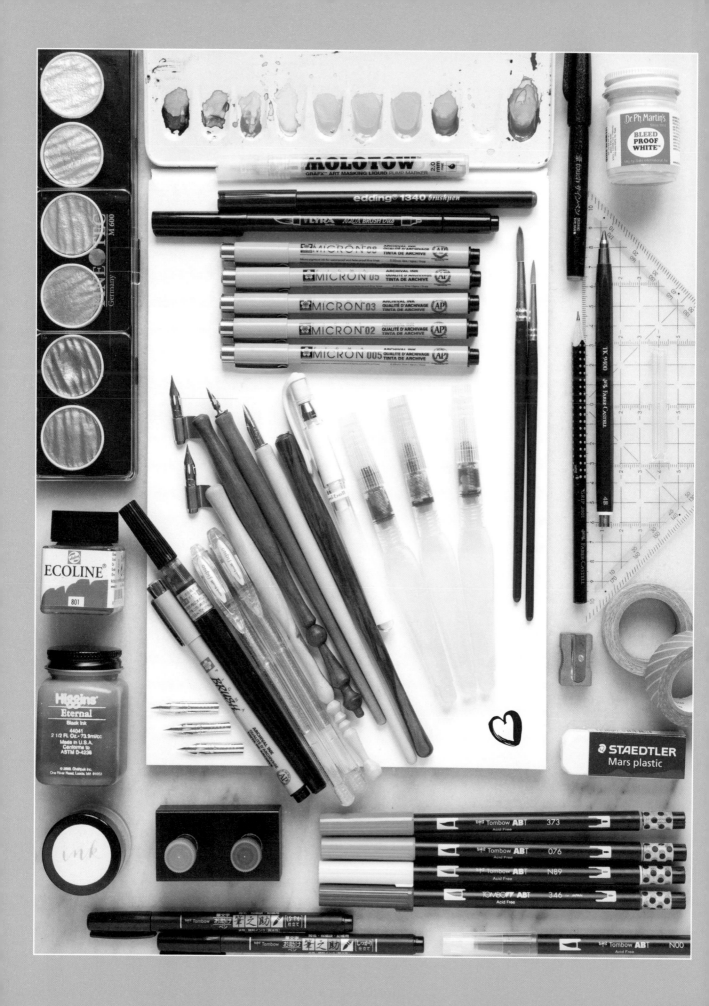

❧ MATERIALS AND EQUIPMENT ❧

I have to admit that I probably spend as much money on pens, paper, brushes and paints as other people spend on shoes and handbags. ;) But don't worry, you can also start lettering without spending a lot, since you probably already have everything that you need to start with at home. Just grab a pencil and/or fineliner, an eraser, a few sheets of plain paper and a suitable grid from this book (on the last pages) and you have all the equipment you need.

This is the essential equipment that I must have on my desk:

Psst!
You can also download all the grids in this book from my website
www.papierliebe.at/vorlagen

PENCILS

- FABER CASTELL (TK 9400) clutch pencil, hardness: 4B
- FABER CASTELL Grip 2001, hardness: B

very soft and soft pencils suitable for sketching, can be erased easily

FINELINERS

- PIGMA MICRON (005/01/02/03/05)
- STAEDTLER pigment liner (0.3/0.5/0.7)

FOUNTAIN PENS/DIP PENS

See page 22

BRUSH PENS

See page 30

PAPER

- RHODIA pad (blank or dots)
- CANSON XL marker pad
- COPIC bleedproof marker pad
- FABRIANO® block Bristol

OTHER WRITING IMPLEMENTS

- MITSUBISHI PENCIL CO., LTD.
 uni-ball Signo PIGMENT INK (white) &
 SPARKLING (silver, gold)
- Edding gel roller (various colours)

EQUIPMENT

- STAEDTLER Mars plastic eraser
- Tombow MONO zero 2.3 eraser (in pen
 form for precision erasing)
- Ruler/protractor (any brand)
- MOLOTOW™ GRAFX™ ART MASKING LIQUID
 (masking pen with pump system), 2.0 fine
- Various pointed brushes
- Watercolour paint box (Schmincke)
- FINETEC colour palette (metallic paints)
- KURETAKE Gansai Tambi (watercolour paints)

There are of course quite a few more things but that would definitely be over the top here!

** I would like to point out that the choice of brands mentioned here is exclusively based on my own personal preference.*

DON'T

wish

for it.

work

FOR IT.

GRIDS

In order to achieve a uniform appearance in your writing at the beginning, it is helpful to work with a "grid". All the letters sit on the baseline and are arranged in a grid with three sections. Lower case letters reach the waistline, upper case letters and letters with ascenders (e.g. "b", "d", "l") reach the top line, letters with descenders (e.g. "g", "j", "y") reach the beard line.

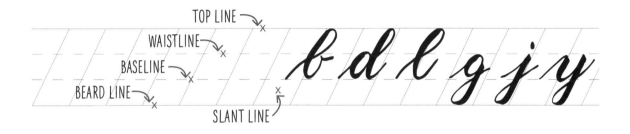

TOP LINE
WAISTLINE
BASELINE
BEARD LINE
SLANT LINE

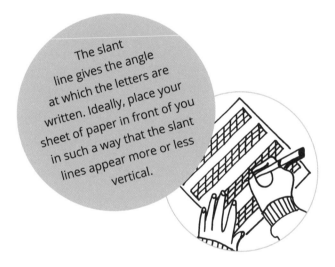

The slant line gives the angle at which the letters are written. Ideally, place your sheet of paper in front of you in such a way that the slant lines appear more or less vertical.

The basic exercises on the following double page are the basis for all the letters. It is a good idea to practise these over and over again - on the one hand, to warm up and on the other hand, to internalise the lines, shapes and curves which subsequently make up the letters. You can also use these exercises to familiarise yourself really well with new writing implements.

TIP:
At the end of this book you will find grids that are already prepared. These templates are very easy to use. To practise, you should ideally place them underneath a sheet of layout paper (approx. 70 g/m2) and secure the edges using washi tape, so that the template cannot slip while you are writing. When you have finished you can simply remove the grid.

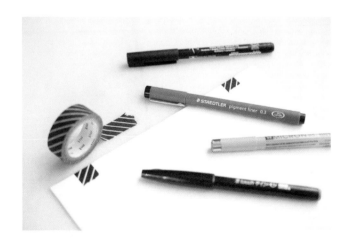

WARM-UP EXERCISES

Start every project with a warm-up exercise. You need time to prepare your fingers, muscles and thoughts for the forthcoming project. First of all, begin with straight lines and then go on with curves and round shapes until you get to the more complex forms. Try to execute all the strokes with the same weight and at the same angle. The spaces between the individual lines and shapes should also be uniform. Take plenty of time for these exercises and do them slowly and deliberately. You can do these exercises with any pen or pencil of your choice. At the beginning, I would recommend that you use a pencil that is not too hard, or a fineliner. You will find exercises for dip pens and brush pens on the following pages.

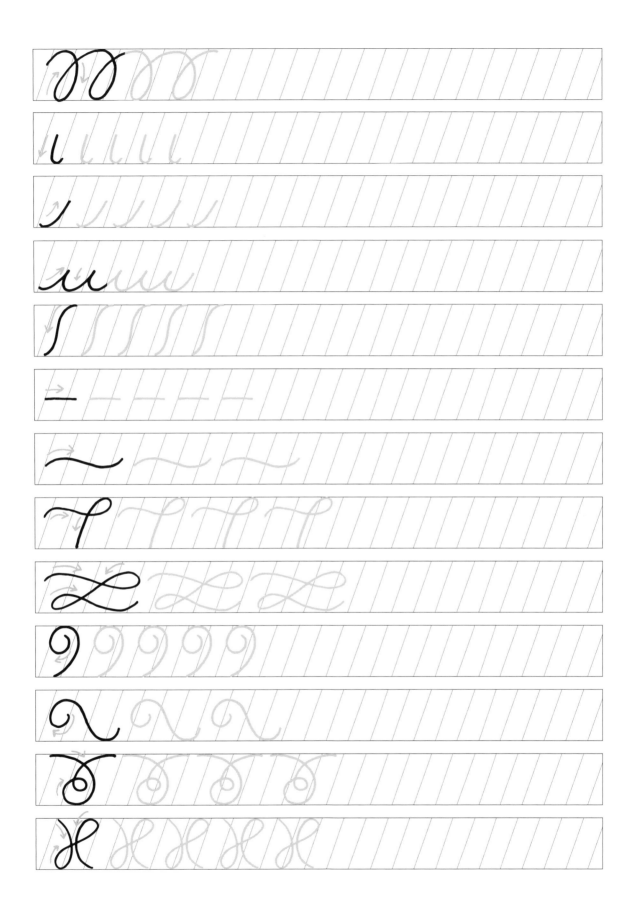

FAUX CALLIGRAPHY

Also known as "fake calligraphy"

Once you are familiar with the basic strokes and shapes, we can turn our attention to the first letters. In calligraphy, the downstroke is carried out with pressure on the dip pen (see page 24), which produces a thicker line. As mentioned earlier, the interplay of thin upward strokes and thick downward strokes creates what is known as the calligraphy effect. Faux calligraphy (using a pencil or fineliner) is an ideal way to understand this principle more fully. **Step 1:** **First of all, write the letters.**

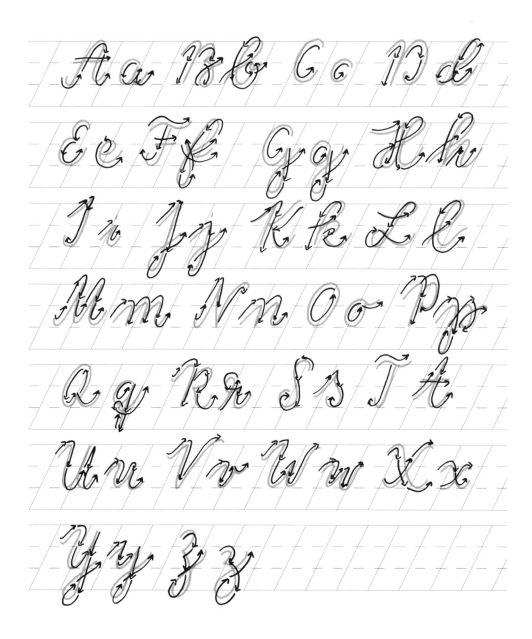

 # FAUX CALLIGRAPHY

Also known as "fake calligraphy"

Step 2: **Reinforce all the downward strokes with a second, offset line.** Think again carefully about where to carry out a downward stroke for each individual letter. You should now reinforce these lines. It may look slightly strange in the case of some letters – especially if the lines cross – but after step 3 you will not notice this anymore. I promise you!

$$Aa \quad Bb \quad Cc \quad Dd$$

$$Ee \quad Ff \quad Gg \quad Hh$$

$$Ii \quad Jj \quad Kk \quad Ll$$

$$Mm \quad Nn \quad Oo \quad Pp$$

$$Qq \quad Rr \quad Ss \quad Tt$$

$$Uu \quad Vv \quad Ww \quad Xx$$

$$Yy \quad Zz$$

FAUX CALLIGRAPHY

Also known as "fake calligraphy"

Step 3: The spaces that you have created between the lines are now filled in. There are no limits on your imagination here. Perhaps you would not just like to fill in or shade in the spaces; colour can also be used to great effect. In any case, you have plenty of additional design options.

Aa Bb Cc Dd
Ee Ff Gg Hh
Ii Jj Kk Ll
Mm Nn Oo Pp
Qq Rr Ss Tt
Uu Vv Ww Xx
Yy Zz

Farbe

Colour

It's your turn!

❧ DIP PENS ☙

Dip pens are primarily used for modern calligraphy. First of all, I will show you the materials, or range of materials, that I like to work with. As well as various pen holders I also have a lot of dip pens. However, I prefer my oblique pen holder with a "Nikko G" nib – this is a modern Japanese nib, which is also suitable for beginners. Although this nib is very stiff, it is possible to draw very thin lines with it.

How to find your favourite nib: the best thing to do is to get a small selection and try them out. In the end it is your personal decision which nib you get along best with.

Top: Speedball Oblique
Low cost oblique pen holder made of plastic

The **"oblique pen holder"** is designed to give a certain angle to your writing, without changing the position of the paper (see also slant lines on page 15).

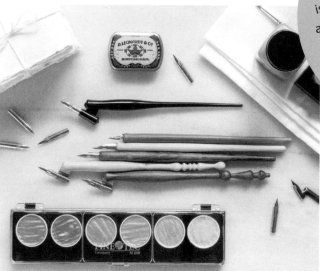

Bottom: normal and oblique pen holders
made from domestically grown wood: Swiss pine, apple, birch, walnut, etc.

Nikko G
Very stiff nib, suitable for beginners, very strong and lasts a long time

Zebra G
Slightly more flexible than the Nikko G, suitable for drawing very fine lines

Brause EF66
The Brause Extra Fine 66 is a very small nib with a more flexible tip

MY FAVORITE PAPER

Canson XL Marker paper (purple wrapper)
Thin, smooth paper which is relatively transparent, but ideally suited for use with a grid placed underneath it.

Rhodia Pad (orange or black)
Likewise beautifully smooth paper and very high quality. The ink does not run.

Tip: Use a few loose sheets of paper as an underlay, so that the writing surface is not so hard.

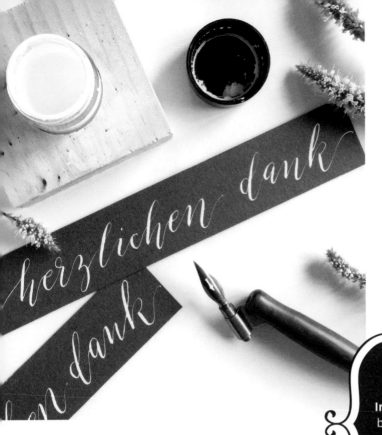

You also need:
a small jar of water and a cloth that does not cause fluff

INK VERSUS INDIAN INK

Ink is thin, water-soluble and not lightfast, but it is good for practising! You can draw very fine lines with it. **Indian ink** is lightfast, contains colour pigments and is therefore slightly more viscous (e.g. for documents).

Higgins Eternal Ink is my first choice when it comes to ink. It has a lovely smooth consistency, which even beginners find easy to write with, and it does not clog up the nib.

Sumi Ink is more viscous and gives a brilliant, shiny surface. It is, however, slightly more difficult to handle, since you have to dilute it with a little water now and then in order to achieve the perfect flow of ink. You also have to clean the nib from time to time, otherwise it clogs up. By the way, the smell of Sumi Ink also takes some getting used to.

I also highly recommend - not just for dip pens and calligraphy – the **liquid watercolours made by ECOLINE**, which come in very beautiful colours.

If you would like to write in white letters on dark paper or card, you should try **BLEED PROOF WHITE™** made by Dr Ph. Martin's.

You can, of course, also use gouache (which needs to be mixed with water to achieve the desired consistency), watercolour paints or walnut ink, since, in terms of inks, etc., it is also a matter of trying different types out and finding your favourite.

My personal insider tip:
FINETEC Pearl Colours with beautiful shimmering colour pigments. They can be diluted with water like watercolour paints and can also be mixed together. The colours produce a simply shiny effect on dark paper or card.

✿ DIP PENS ✿

Now that you are familiar with the principles of "Faux Calligraphy" we can work with the dip pen and the true calligraphy effect. Here, the various weights of the strokes arise from the different amount of pressure applied to the nib (= swells).

Strichstärken
Stroke weights

UPSTROKE
(upwards stroke)

DOWNSTROKE
(downwards stroke)

MIDDLE STROKE

In order to achieve as **thin** a line as possible and so that the nib does not scratch the paper, as little pressure as possible should be applied to carry out the upstroke.

When carrying out the downstroke the nib tip is spread by applying slight pressure to the nib so that a greater quantity of ink can flow – thus creating a **thick line**.

The middle stroke is carried out using as little pressure as with the upstroke. Examples of the horizontal (middle) line are the cross bars of the letters "A" or "t".

Gut zu wissen
Good to know

Dip the nib into the ink pot until the reservoir (the small hole in the middle) is filled.

- If the ink does not flow properly, clean the nib with water and a dry cloth that does not cause fluff.
- With a new nib, the ink may be slow to flow at first. In this case, heat the nib tip with a lighter for a moment. Next, clean it again with water and a cloth and then you should be able to write properly!

WARM-UP EXERCISES

First of all, it is important to familiarise yourself with the nib and the ink. Start with the following exercises and do them very slowly. The aim is to produce constant lines and to not let the nib scratch over the paper. Hold the pen holder in a comfortable and relaxed way in your hand – do not let your hand be cramped otherwise your fingers and hand will soon start to ache. After all, writing with the dip pen should be relaxing and enjoyable.

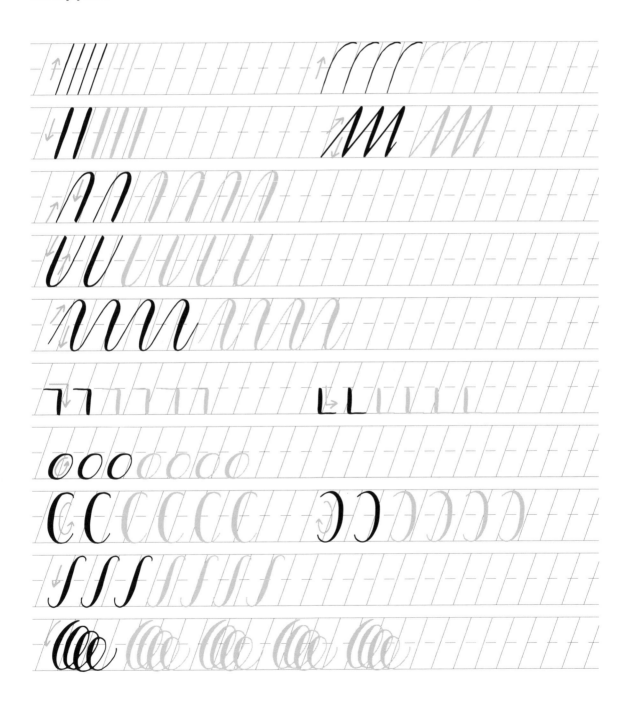

Aa Bb Cc Dd Ee

Ff Gg Hh Ii Jj Kk

Ll Mm Nn Oo Pp

Qq Rr Ss Tt Uu

Vv Ww Xx Yy Zz

Space To Practice

Now it's your turn! Here you have space to practise the letters. The alphabet on the left-hand side is intended to act as a guide. Practise each individual letter over and over again – think back to primary school, how you learned each individual letter from scratch in those days. The more you practise, the easier it will become to write the letters. When you have got the hang of them, you will probably also have found your own style.

Aa Aa

❧ DIP PENS ❧

IT'S ALL A QUESTION OF STYLE

There are many different styles of calligraphy – each one is unique. Look at the different examples and let yourself be inspired. Perhaps your personal style is a combination of different design variations.

your style
NORMAL

your style
WIDE AND CONSISTENT

your style
ANGULAR

your style
SMALL
(Letters about the same height)

your style
WIDE AND ROUND

your style
SOFT AND ROUND

your style
FLOURISHES

your style
ALTERNATING
(variable baseline)

28

Signpost

Love is the only thing that grows when we waste it.

It is what it is,
says Love

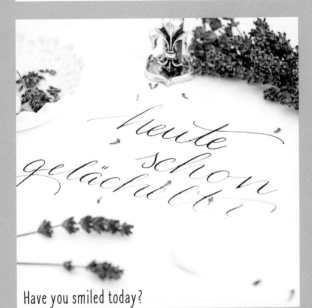

Have you smiled today?

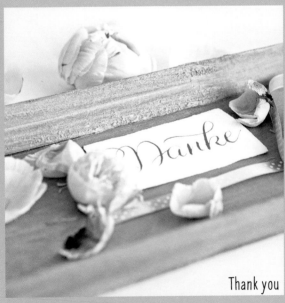

Thank you

BRUSH PENS

Brush pens are pens with tips like brushes. These pens can be roughly divided into two groups:
- **Brush pens with felt sponge tips[1]** (similar to a felt tip) –
 here the tip consists of a flexible homogeneous sponge
- **Brush pens with individual fine hairs[2]** (similar to a conventional brush)

It is much easier to write with a brush pen than with a natural hair paintbrush, since you have the brush tip more under control. Another considerable advantage is that these pens contain ink cartridges that can sometimes even be replaced. Brush pens are available in many different versions and colours. The following is a small selection.

Tombow Fudenosuke[1]
WS-BH (hard)

Tombow Fudenosuke[1]
WS-BS (soft)

Pentel Sign Pen[1]

LYRA Aqua Brush Duo[1]

Tombow Dual Brush Pen[1]

Pentel Brush Pen[2]

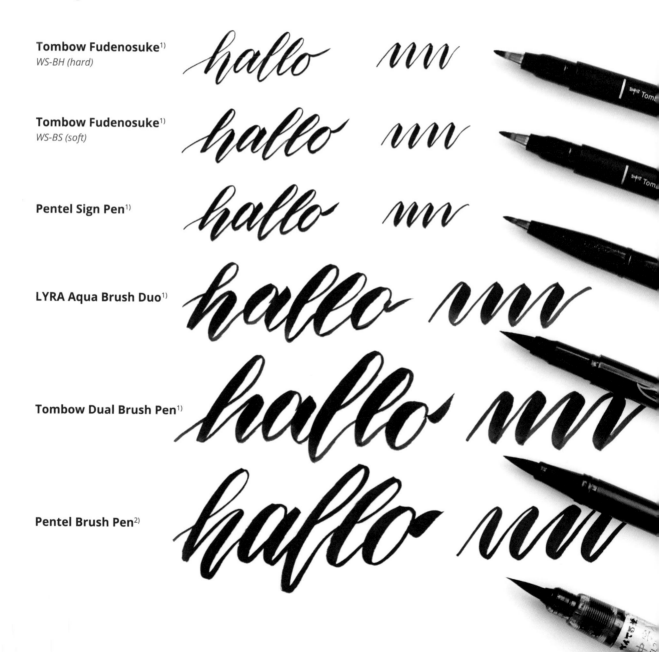

BRUSH PENS

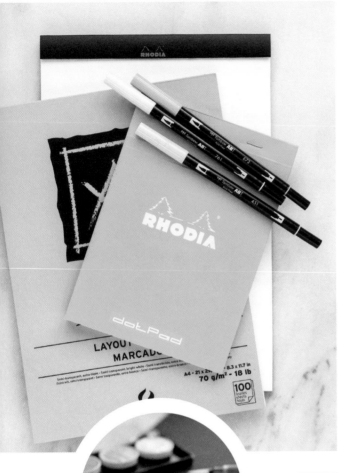

The choice of paper for use with synthetic brush pens is particularly important! My initial ignorance ruined a lot of pens in a very short period of time. I recommend that you only use brush pens on extremely smooth paper. Do a test by stroking the paper with the palm of your hand. If it feels smooth and even, you can assume that the paper is suitable for your pens. For my brush lettering projects, I generally use the same types of paper as for dip pens (see page 22).

By the way, Rhodia Pads are also available with a dotted pattern (= Rhodia Dot Pad). This can also be very helpful in the beginning, since the discreet dots in the background provide a simple guideline without being too obtrusive.

I very much like **Bristol paper** for watercolour paints. This is a robust, 250gsm paper with a smooth surface.

If you would like to work with watercolour paints or gouache, I highly recommend **Pentel Aquash-**brush pens[2]. These brush pens have an integrated water chamber and they come in three different sizes.

Of course, normal pointed brushes can also be used for brush lettering

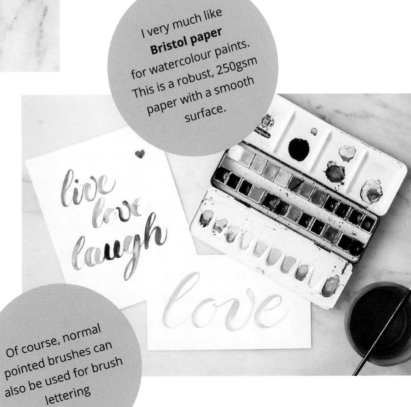

WARM-UP EXERCISES

Just like with dip pens, we also use swell strokes in brush lettering. For the downward stroke, press the tip of the brush firmly on the paper in order to create a thick line. For the upward stroke, let the tip glide softly over the paper, so that a thin line is created.

DOWNSTROKE
(Downwards stroke)

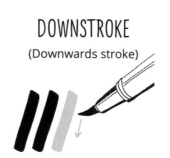

UPSTROKE
(Upwards stroke)

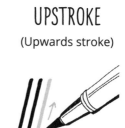

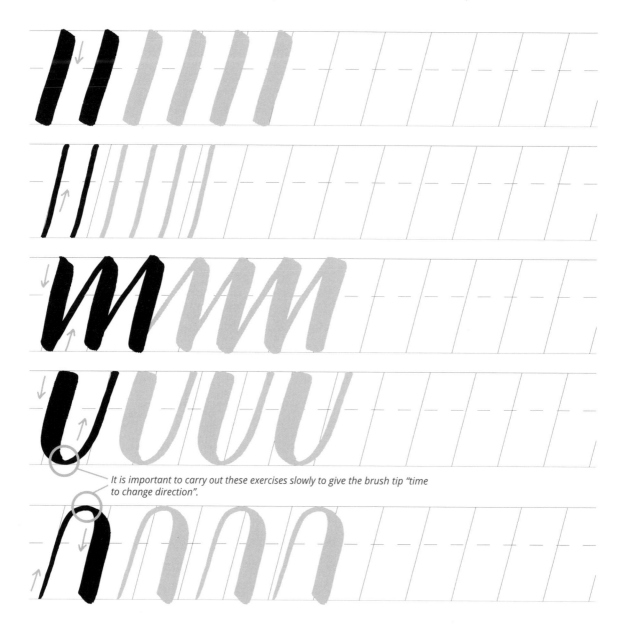

It is important to carry out these exercises slowly to give the brush tip "time to change direction".

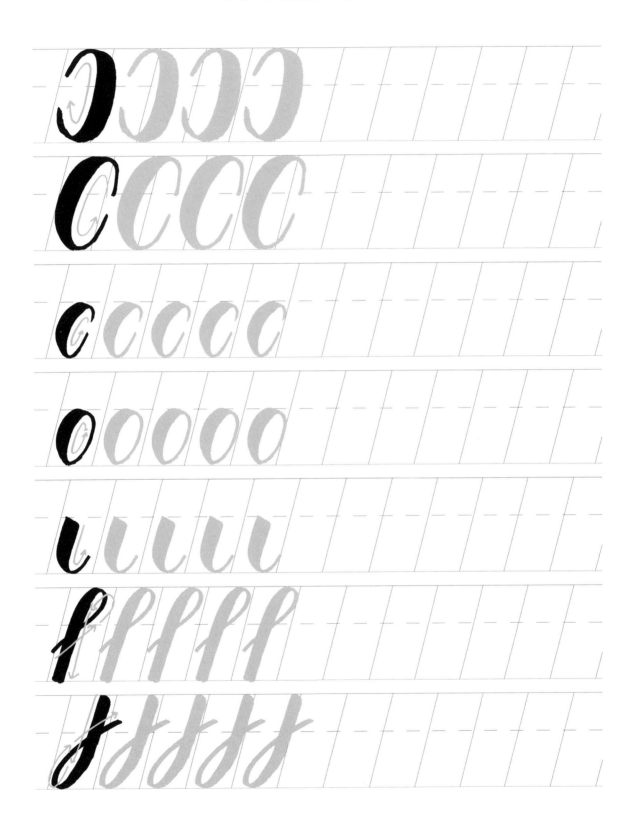

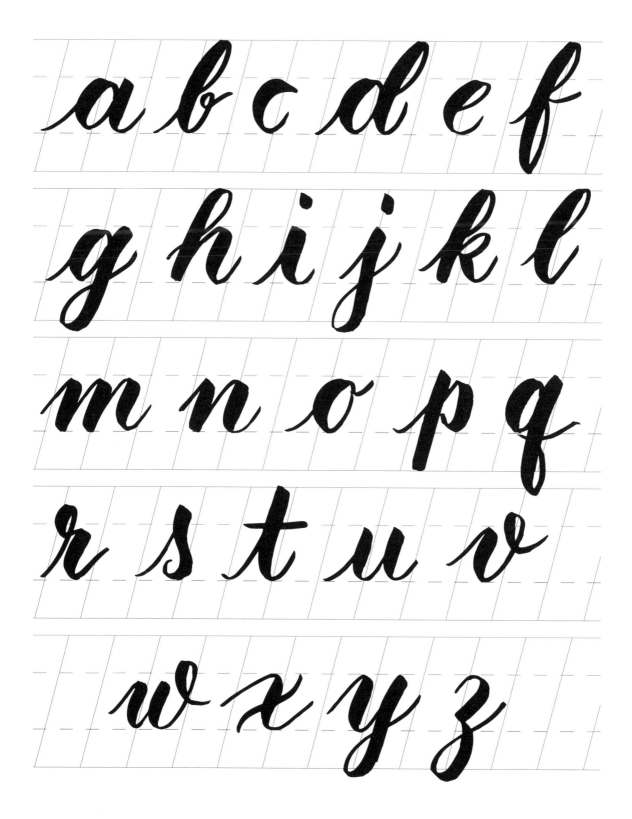

Now it's your turn again! Practise the letters to get a feel for the sequence of movements and, as always, be careful to make thin upstrokes and thick downstrokes. The more often you write the letters, the more familiar you will become with the sequence of strokes, and soon you will be able to produce complete words and sentences. On the following pages you will find plenty of space to practise.

CAPITAL/MAJUSCULE LETTERS

A B C D E

F G H I J K

L M N O P

Q R S T U

V W X Y Z

After practising the lower case letters, you can now move on to upper case letters. This alphabet has been created in the course of my career in lettering and calligraphy and is intended to provide you with a basic guide. After a little practice, you will quickly notice that you are producing your own creations and you will develop your own alphabet.

❧ FLOURISHES ❧

SWEEPING FLOURISHES

Now we are going to add a bit more dynamism and fun to our lettering, with sweeping features which you can create individually – below, above, in front of or after the letters. There is no right or wrong approach and anything that you like is allowed! Flourishes could be described as the "accessory" to our lettering. Used in appropriate measure and purposefully, it can produce a beautiful effect and really liven up your written text. Here is an example and a few basic flourishes.

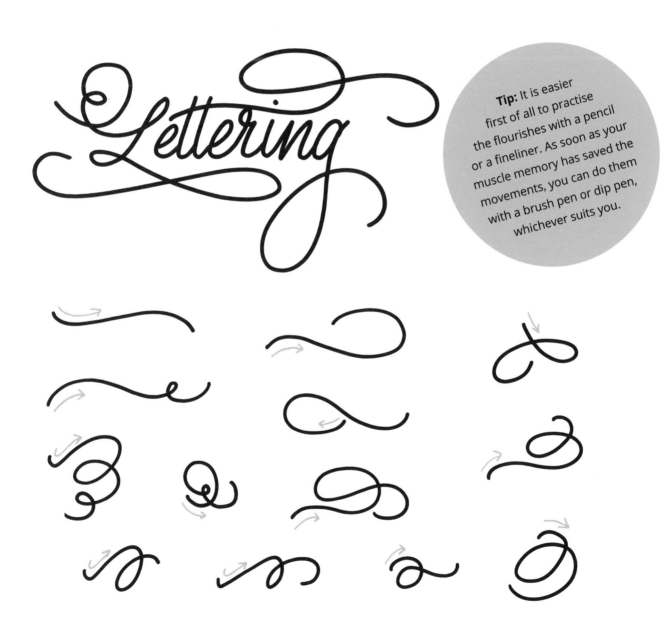

Tip: It is easier first of all to practise the flourishes with a pencil or a fineliner. As soon as your muscle memory has saved the movements, you can do them with a brush pen or dip pen, whichever suits you.

DECORATIVE FEATURES

In addition to flourishing, you can also embellish your lettering with other features:
scrolls, flowers, leaves, hearts, arrows and much more. Even if it is just a limited selection, here are a few ideas for your own creations.

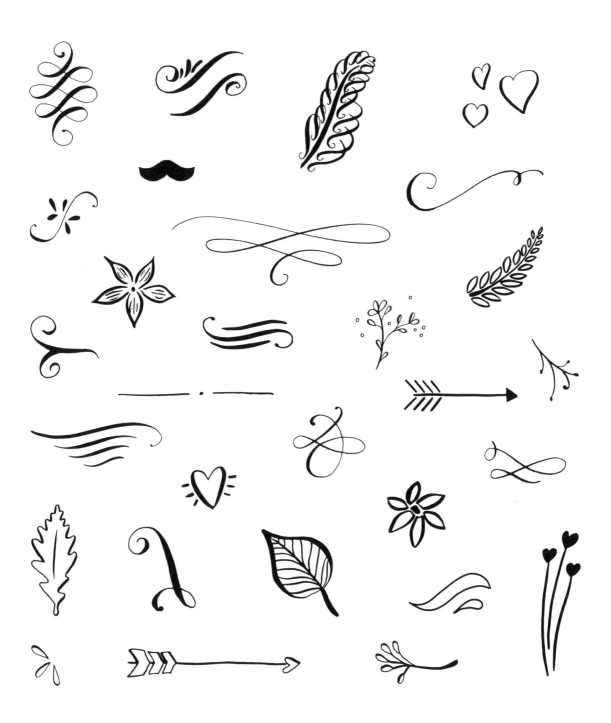

DECORATIVE FEATURES

TENDRILS AND GARLANDS

You can also embellish your words, sentences and quotations in a very beautiful way using tendrils and garlands. You can create simple but effective garlands, for example, with the synthetic tips of brush pens: draw a circle[1] (I simply use a washi tape roll for this) with one or more lines and add a few "drops" along the lines at irregular intervals[2]. The whole thing looks even better if you add a few spots[3]. It does not have to be perfect!

You can also create these decorative features using a fineliner or another type of drawing pencil and adapt them to suit your lettering project depending on its size and length.

Drop technique: press the tip of the pen once firmly on the paper. You have just produced your first leaf.

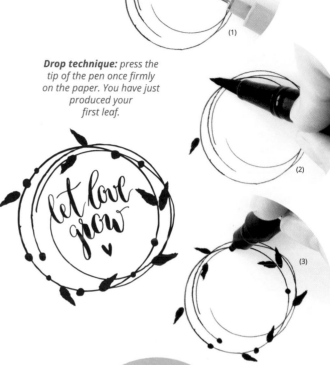

Tip:
You can also create a heart shape very easily using this "drop technique":

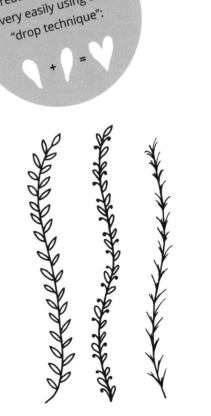

❧ DECORATIVE FEATURES ❧

BANNERS

You have probably wondered at some point what the best way to construct a banner is. To be honest, this was always a big question for me. In the meantime, I have discovered a very simple way of creating banners, which I will show in this step-by-step guide. ;)

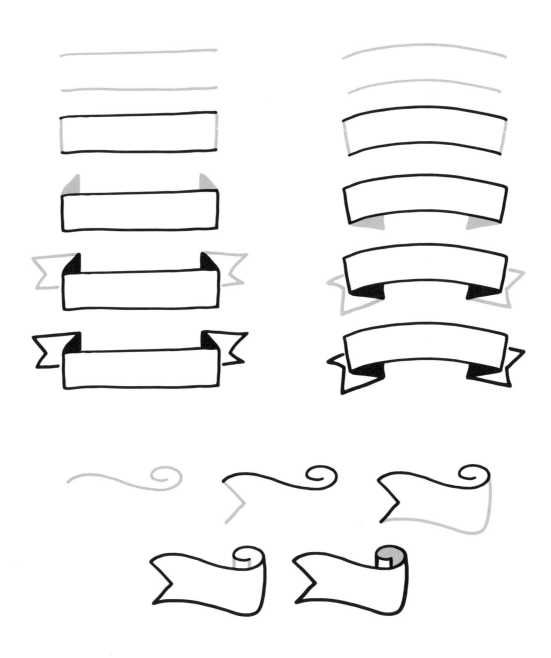

SANS SERIF FONTS

With hand lettering, you can really play around with contrasting styles of writing, for example, combining a sans serif font with brush lettering. Sans serif fonts have a trendy, up-to-date appearance and can be combined to great effect with decorative or ornate lettering. You can make the letters narrow or wide and you can vary the x-height so that you create a new look every time.

NARROW & CENTRED X-HEIGHT

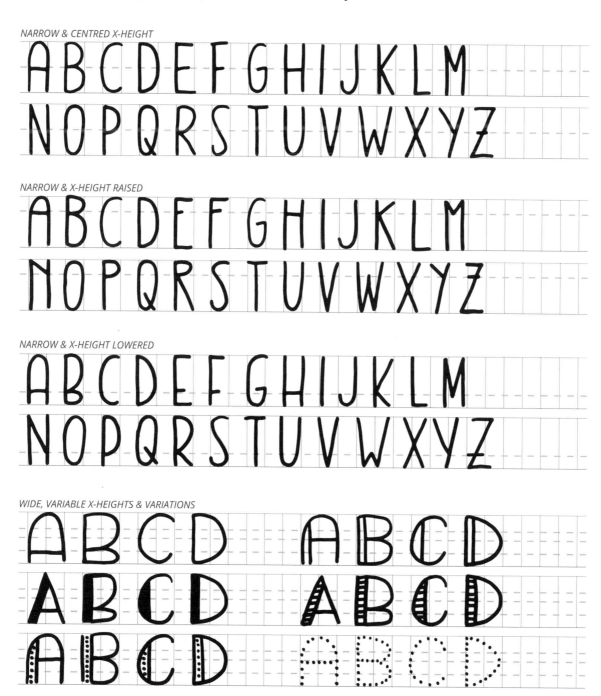

NARROW & X-HEIGHT RAISED

NARROW & X-HEIGHT LOWERED

WIDE, VARIABLE X-HEIGHTS & VARIATIONS

SANS SERIF FONTS

You can practise here!

❧ SERIF FONTS ❧

The small transverse strokes (little "feet") attached to the ends of letters are known as serifs. This style of writing is also particularly suitable for use as a contrast in hand lettering. Personally, I generally use a very narrow modern font with serifs.

NARROW & VARIABLE X-HEIGHT

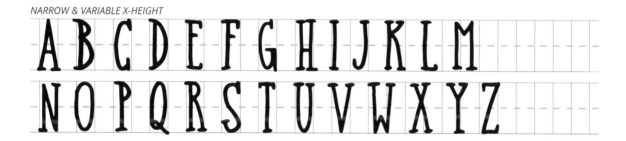

The x-height can also be made variable here. I have already shown you how this works on the previous page. **Just try out a few variations yourself.**

PERFECTLY - IMPERFECT

A B C D E F
G H I J K L M
N O P Q R S T
U V W X Y Z

a b c d e f g h i j k l m
n o p q r s t u v w x y z

ABCDEFGHIJKLM
NOPQRSTUVWXYZ

❧ NUMBERS ☙

When lettering, we do not only use letters, of course, but also numbers, for example when addressing an envelope, or on a birthday or 'save-the-date' card. In this case the numbers may even appear very large in the foreground and can be quite simple, but they may also be highly decorative and detailed.

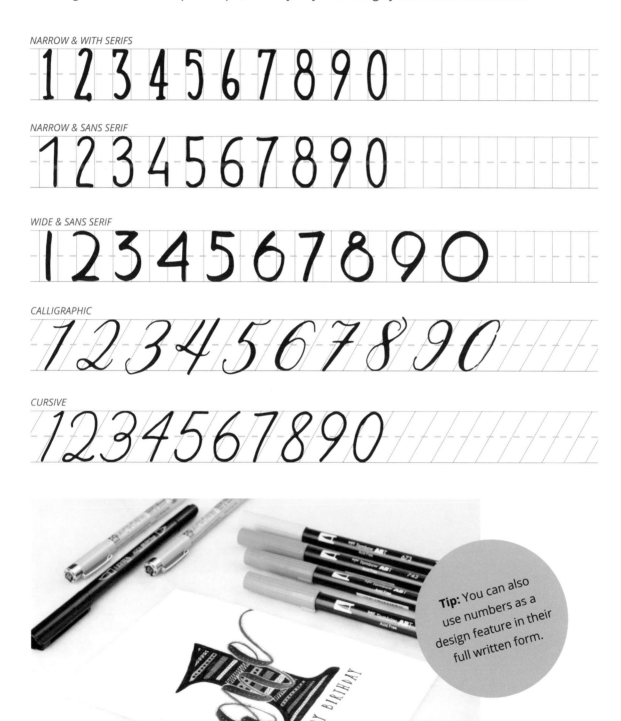

NARROW & WITH SERIFS

1 2 3 4 5 6 7 8 9 0

NARROW & SANS SERIF

1 2 3 4 5 6 7 8 9 0

WIDE & SANS SERIF

1 2 3 4 5 6 7 8 9 0

CALLIGRAPHIC

1 2 3 4 5 6 7 8 9 0

CURSIVE

1 2 3 4 5 6 7 8 9 0

Tip: You can also use numbers as a design feature in their full written form.

✎ THE AMPERSAND ✎

In hand lettering, you can also make good use of the ampersand as an eye-catching feature. For example, if you have an "and" in your quotation or phrase, replace it with an "&" and you will also jazz up your lettering. This symbol is also an excellent choice as a design feature for monograms, wedding invitations or 'save-the-date' cards. You can equally well use the word "and" in its full written form, however, and make it stand out with little visual highlights.

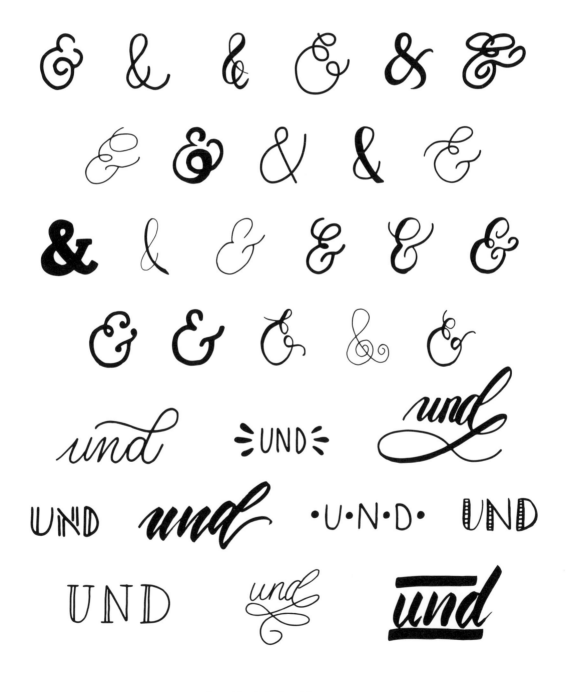

"und" with "and"

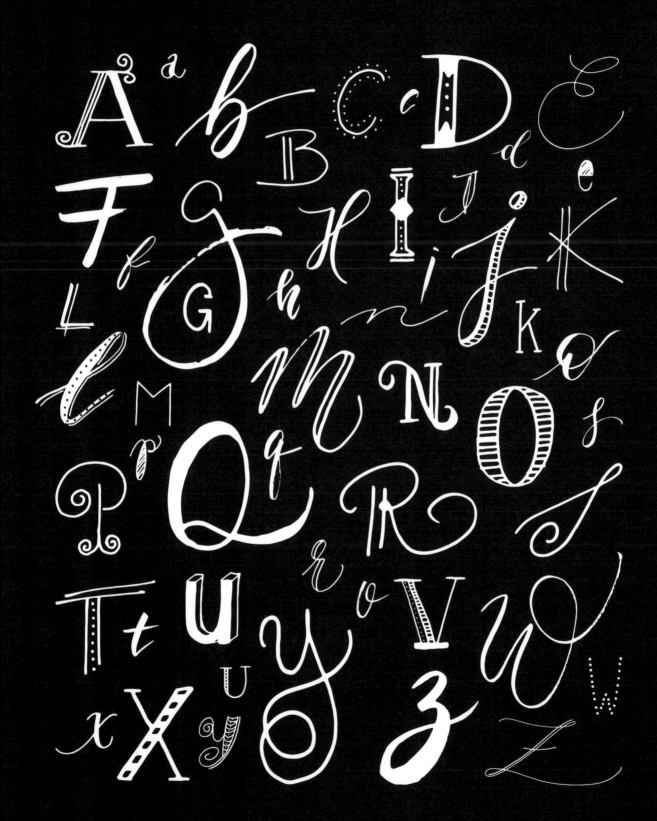

❧ A POTPOURRI OF LETTERS ❧

There is an infinite variety of design options for letters. This page is left blank for you to let your imagination run free.

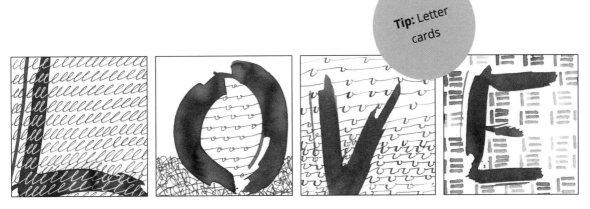

Tip: Letter cards

What you need: square cards and various writing materials
What to do: draw a letter on each card (as above, e.g. "LOVE") and create different patterns in the areas surrounding the individual letters. When you have finished, you can stick the cards on a piece of coloured cardboard, for instance.

✧ ALTERNATIVE GRIDS ✧

In our design playground, there are even more ways to put letters and words on to paper. Until now, we have been working exclusively with a straight line grid but this does not always have to be the case. Here are a few examples of how you can use wavy, circular or even heart-shaped designs in a fun way. It may look complicated, but the principle always remains the same as for a straight line grid.

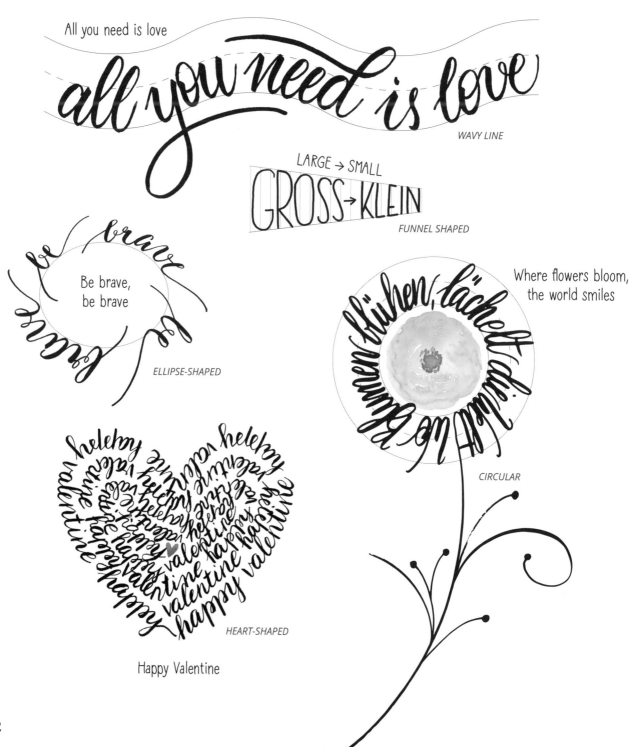

All you need is love

WAVY LINE

LARGE → SMALL

FUNNEL SHAPED

Be brave, be brave

ELLIPSE-SHAPED

Where flowers bloom, the world smiles

CIRCULAR

HEART-SHAPED

Happy Valentine

❧ BOUNCE LETTERING ❧

You could also describe bounce lettering as lettering that "hops" or "dances". As we did with the alternative grids, we are now breaking the rule that all the letters must be aligned on the baseline and simply arranging them in a more dynamic way, sometimes above the baseline, sometimes below it. The individual letters are perhaps not always placed at the same angle. This makes the visual appearance even more interesting and individual. Anyone who is familiar with my work will know that I love bounce lettering. :)

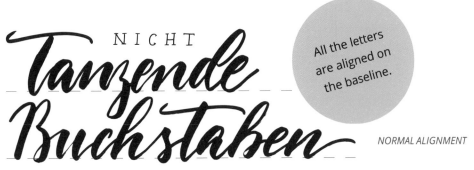

NICHT
Tanzende Buchstaben

NON- dancing letters

All the letters are aligned on the baseline.

NORMAL ALIGNMENT

Letters not aligned in a uniform way on the baseline.

BOUNCE LETTERING

Tanzende Buchstaben

Dancing letters

You can try this out for yourself right here:

✤ ADDITIONAL EFFECTS ✤

What I particularly like about hand lettering is the endless variety of options for creating letters in different shapes and colours. For this reason, I would like to show you a few more tricks to help you spice up your lettering projects in a simple and effective way.

blending fun

BLENDING is a term used for a technique in which two colours are mixed together or blended while we are in the process of writing. To do this, you can use any water-based brush pens. For example, I use my Towbow Dual or Aqua Brush Pens.

What you need:
Two colouring pens of your choice, a piece of cling film or a freezer bag and some paper

What to do:

- Place a little colour from the first pen on the cling film.[1]
- Pick up the colour with the second colouring pen.[2] When the tip of the pen appears to change colour, that is just right – don't worry, it will not damage your colouring pen and can be removed completely afterwards!
- Now you can write your word[3] and you will see that the colour of your pen changes while you are writing and goes back to its original colour. You can repeat the process several times if necessary. If there is still some "foreign" colour on the pen tip at the end, write on a second sheet of paper until the pen tip reverts to its own colour shade.

By the way, "blending" also works very well with the liquid watercolour paints produced by ECOLINE[4]. Simply dip the tip of the pen in the colour pot and you can write with it straight away.

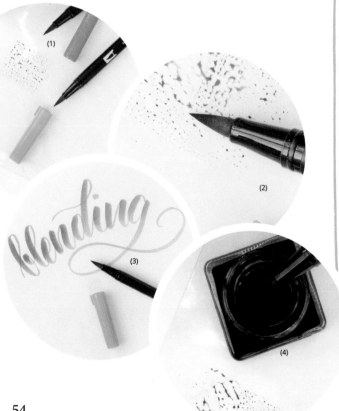

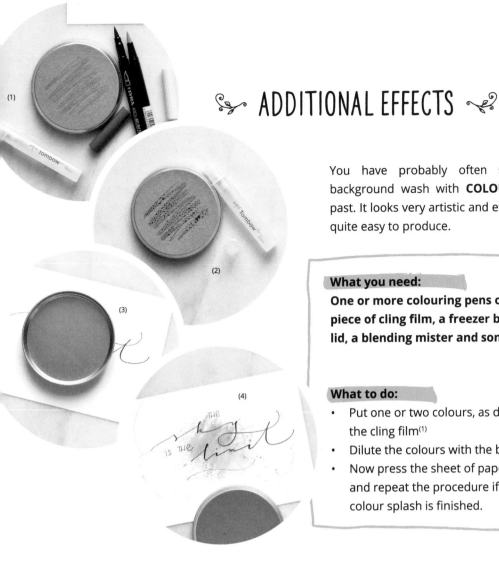

✎ ADDITIONAL EFFECTS ✎

You have probably often seen a watercolour background wash with **COLOUR SPLASHES** in the past. It looks very artistic and effective and is actually quite easy to produce.

What you need:
One or more colouring pens of your choice, a piece of cling film, a freezer bag or a flat jam jar lid, a blending mister and some paper

What to do:
- Put one or two colours, as desired, on the lid or the cling film[1]
- Dilute the colours with the blending mister[2]
- Now press the sheet of paper on the cling film[3] and repeat the procedure if required – and your colour splash is finished.

You can also achieve lovely effects with **MASKING FLUID**:

- First of all, write the word you want with masking fluid – it is available as a marker pen (e.g. from MOLOTOW™) or in liquid form for use with a brush (e.g. from Winsor & Newton).
- Leave until thoroughly dry.
- Next, you can add your coloured background to the paper (e.g. with watercolour paint) – you don't need to worry about the written text; the masking fluid acts as a protective shield.
- Leave again until thoroughly dry. It is better to wait a little longer, rather than destroy your artwork – I speak from experience ...
- ... And now the fun of erasing starts. You can rub off the masking fluid quite easily using your finger or with an eraser.
- Et voilà – your artwork is finished!

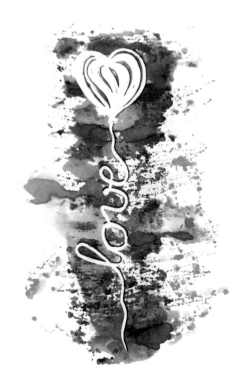

❧ BLOCKING ❧

Now that I have shown you a few design options, we can finally dare to embark on our first joint lettering venture. For this, I have chosen the phrase "Ready to start your very own Lettering – or coffee first?" In each sentence there are key words that you want to emphasise and fillers that have less significance. In order to design the phrase in the best possible way, you need to separate the individual words into groups or blocks, from which we also derive the term "blocking". This allows you to plan each lettering project very well.

The key message[1]

Before I start the actual blocking and the first sketches, I write the phrase down and think about the weight of meaning that the individual words have for me. I highlight the important words by underlining or circling them. This then forms the basis of the blocking.

The basic arrangement[2]

First of all, I draw the desired final format of our lettering project including the centre line, since I want to make sure the phrase is centred on the page. I always do this with a ruler. You can, however, also align the phrase to the left or to the right – or you can justify it, of course.

Then I think about how I want to arrange the words of my phrase and divide them roughly into so-called blocks. I draw the lines, proportions and curves with a pencil until I have them in the desired layout. You are allowed to erase, of course. ;) And even if the lines are not yet exactly aligned, it doesn't matter – this is just a rough sketch.

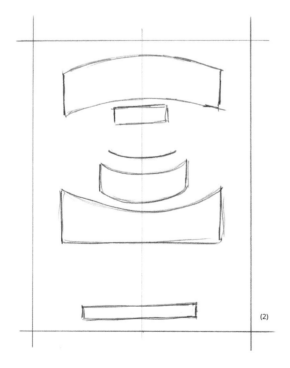

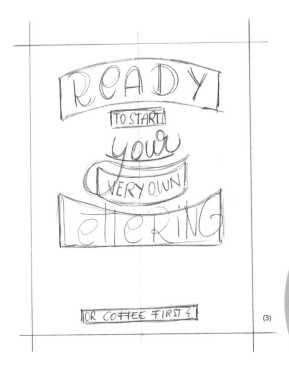

(3)

Text-Arrangement[3]

When I am satisfied with the arrangement of the blocks, I insert the desired text in respective fields. Here too, it is initially just a rough arrangement of the words. The detailed elaboration of the fonts and the individual letters is undertaken in the next stage.

Tip: Use transparent or marker paper for your blocking work. This allows you to trace and rework each step several times without having to erase too much. You may also like to have a look at several versions of letters, so that you can compare them better.

The finishing touches and additional design features[4]

Now the time has come to think about the individual letters and their design. Different fonts add excitement to your lettering project and additional design features complete the layout. You can work with banners and flourishes and all the tips and tricks you have seen in this book. There are no limits to your imagination.

When the pencil sketch is ready, all that remains is the final artwork. For this I use a very thin, black fineliner. In order to avoid tiresome erasing afterwards, I always work with marker paper, which allows me to trace my sketch easily and to do it again if necessary.

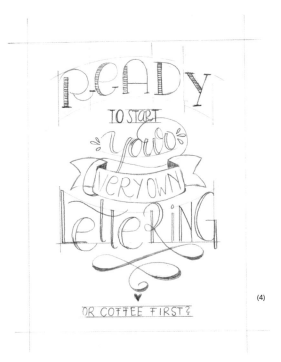

(4)

READY
TO START
your
VERY·OWN
Lettering
OR·COFFEE·FIRST?

SPACE FOR YOUR OWN FIRST HAND LETTERING PROJECT

❧ MONOGRAMS ❧

In the traditional sense, a monogram is an artistic arrangement of the two initial letters of a person's first and last names. For wedding stationery, a monogram of the couple can be used: for this you simply take the initial letters of the bride and groom's first names. Hand lettering is ideally suited for the creative realisation of this task – there are no limits on your imagination - with a choice ranging from classical to modern to playful interpretations.

MY WORKING PROCEDURE

First of all, I sketch my ideas on a piece of paper using a pencil.[1] When I like a version, I think about which writing tool would be most suitable to produce it - there may be several different ones. For my example (see right) I chose a dip pen and ink. Then it is time to put my chosen idea into practice. At this stage, I generally need several attempts with various approaches until I achieve the desired result. I write or draw the letters as often as it takes until I finally like them.[2] It is also possible, of course, that I do the final touches on the computer, since I usually have to produce a digital copy of the monogram anyway for further processing and copying.

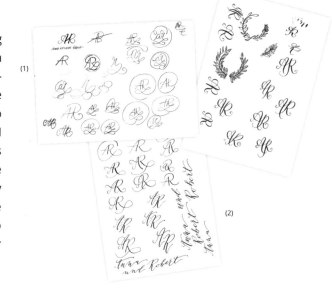

(1)

(2)

TIP: Try writing and/or drawing different versions of the selected letters and think about how these letters could be interlinked in an attractive way. Legibility is not necessarily the most important factor in this context.

Further examples of my monogram could look like this:

I prefer modern monograms, which are kept rather simple and do not have too many flourishes. This makes it easy for me to integrate the initials as features into an existing design or to further enhance them with graphical elements.

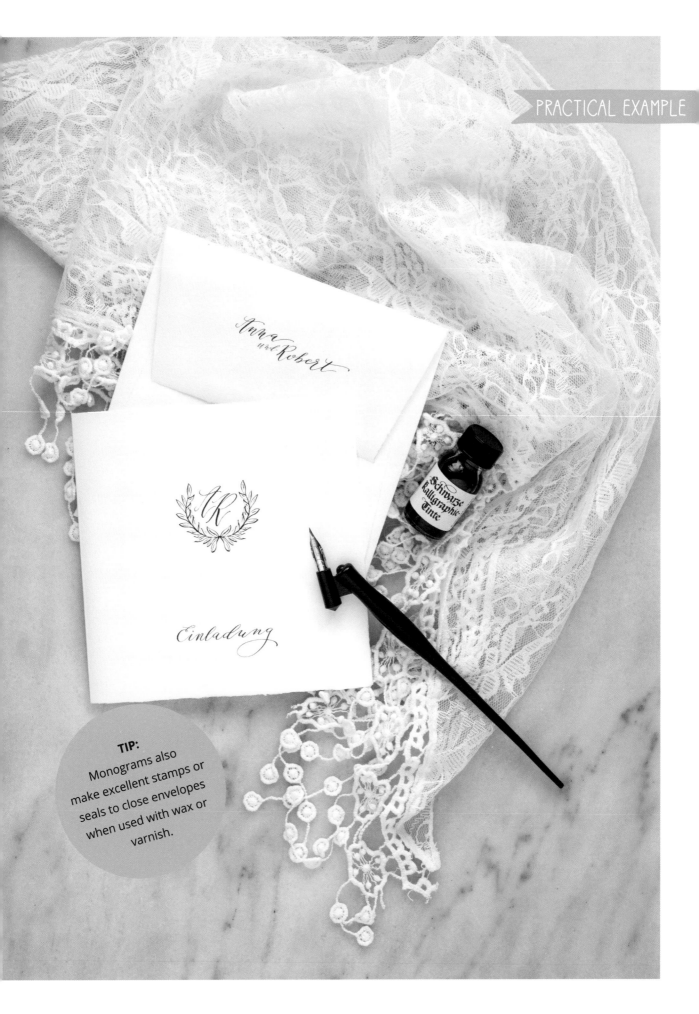

TIP:
Monograms also make excellent stamps or seals to close envelopes when used with wax or varnish.

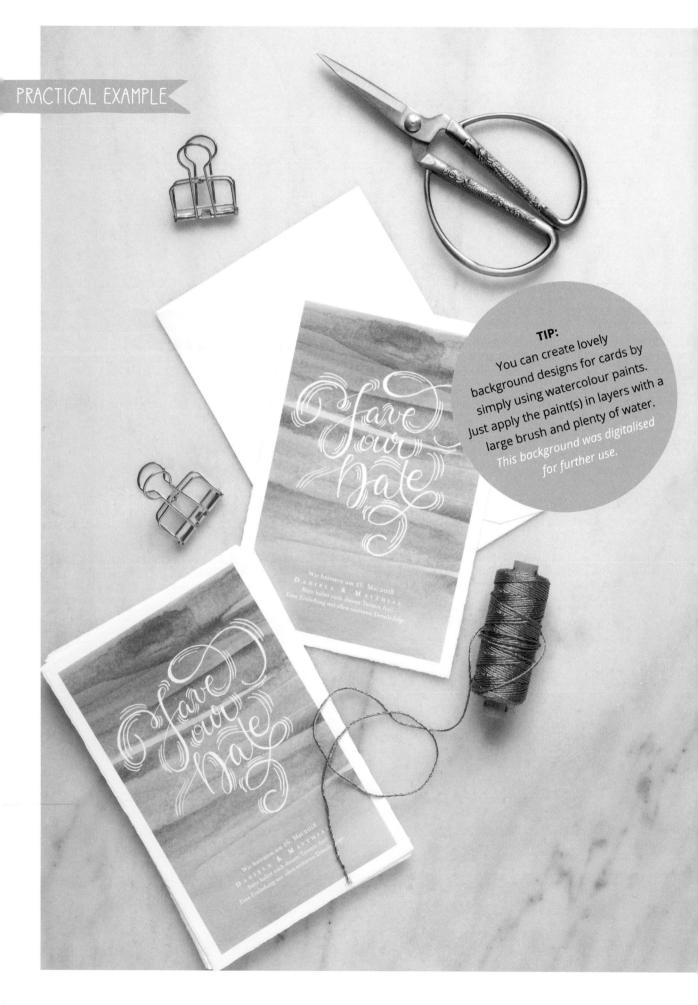

TIP:
You can create lovely background designs for cards by simply using watercolour paints. Just apply the paint(s) in layers with a large brush and plenty of water. This background was digitalised for further use.

Since not all the information for the invitation is usually available when you start planning a wedding, it is a good idea to send 'save-the-date' cards to announce the date of the wedding in advance to the guests. Here I will show you a few examples of what the hand lettering text for these cards could look like.

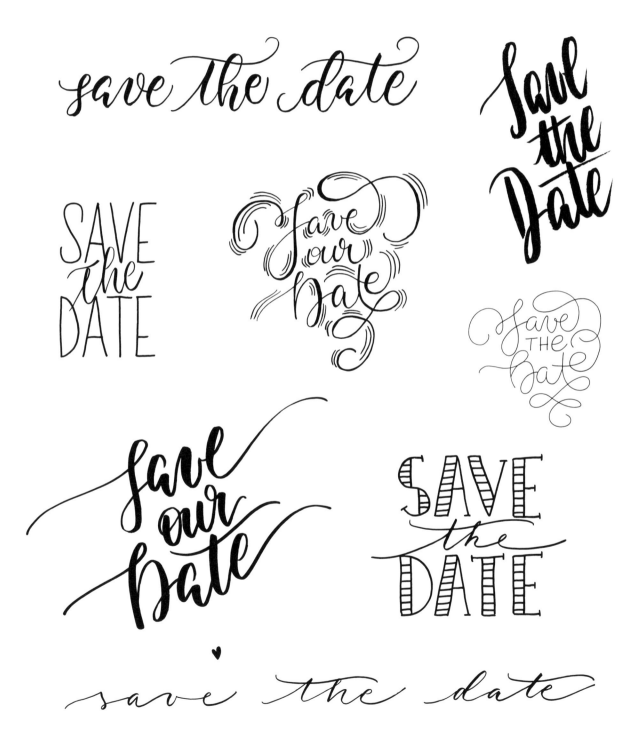

INVITATION

Invitations can also be beautifully created using hand lettering. Whether it is a wedding or a birthday - any occasion deserves an attractive invitation. If you like, you can even write the entire invitation by hand - in "mix and match style"(1) with different fonts it looks especially interesting. Simply try out some different styles with various writing implements.

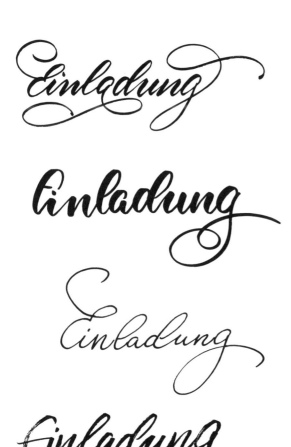

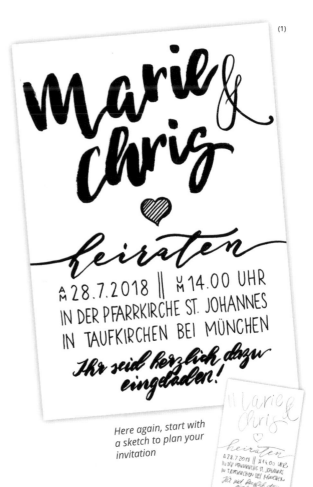

(1)

Here again, start with a sketch to plan your invitation

If you digitalise your lettering text, you can create as many variations as you like afterwards.

ulrike & thomas
sagen ja

Remember:
less is often more

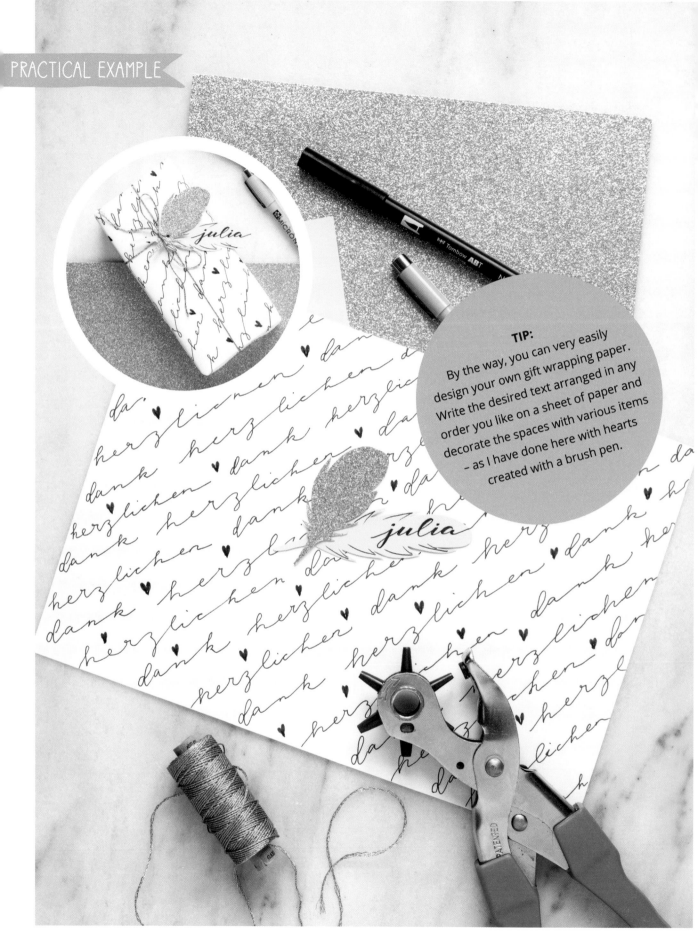

TIP:

By the way, you can very easily design your own gift wrapping paper. Write the desired text arranged in any order you like on a sheet of paper and decorate the spaces with various items – as I have done here with hearts created with a brush pen.

GIFT TAGS

Giving presents is a source of pleasure - especially when a gift is really beautifully wrapped and is adorned with a hand-made gift tag. You can design your own shapes or use ready-made cards or cutting dies[1]. There are innumerable possible shapes for tags that can be decorated with attractive lettering - they do not always have to be round or rectangular!

(1)

For example, how about a gift tag shaped like a feather? You can find some great templates and paper designs at **www.monbijou-geschenke.de!**

Feather template 1

Feather template 2

What you need:
Coloured card, pencil, tracing paper (white for dark-coloured, and black for light-coloured card), scissors or craft knife, fineliner, feather template (1 and/or 2), hole punch pliers

What to do:
- Transfer the desired feather template to your card using tracing paper
- Cut the template out
- Mark your feather card individually with a name or phrases and further decorate the feather as desired
- Punch a hole for the string preferably using hole punch pliers

Have I already mentioned that I love washi tape? This tape is just so multifunctional and is ideal for making designs – such as decorative stripes on gift tags.

67

NAME CARDS

A beautifully laid table with hand-written name cards will attract attention at any party. You don't necessarily have to use hand lettering on paper for this - there are many other options: stones, shells, slate tablets, glass or leaves, for example, can all be used - depending what is in keeping with the theme. You can really get artistic here. Since you need to use a permanent marker for many of the above-mentioned surfaces so that the lettering is durable, faux calligraphy is a good choice for this purpose (see page 18).

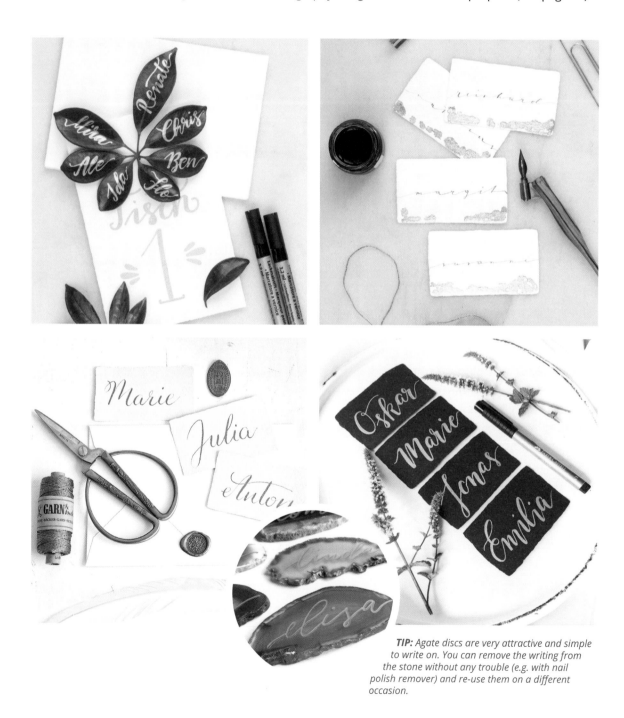

TIP: Agate discs are very attractive and simple to write on. You can remove the writing from the stone without any trouble (e.g. with nail polish remover) and re-use them on a different occasion.

It is not only name cards that are in particular demand for big celebrations, but also table numbers. If there is free seating at the tables, you can combine the table numbers with the names. Otherwise, you can design the numbers as stand alone items. I will show you an example of one of these with step-by-step instructions – this time with a dip dye background.

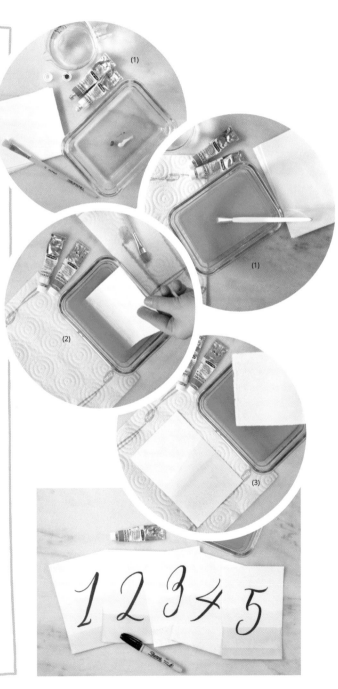

What you need:

A6 cards (e.g. from handmade paper), an empty container, watercolour paints or gouache in a tube, water, cloths (kitchen roll or paper towels) and 1 or 2 heavy books for drying the cards, permanent marker pen (e.g. Sharpie)

What to do:

- Mix the desired colour with water[1] – you can also mix several colours together to produce a favourite colour. The more liquid you have, the higher you can make the background on your card.
- Dip the card into the container up to the desired level.[2]
- Wait about 20 seconds, then carry out the procedure again to a slightly lower level[3] (this creates the graduated background effect), and repeat this step once or twice more if necessary.
- Lay the card on a cloth to dry (e.g. kitchen roll).
- When the card has dried sufficiently but is not completely dry, you can weigh it down with a book, thus preventing it from curling.
- Finally, write the desired number on the card with the marker pen.

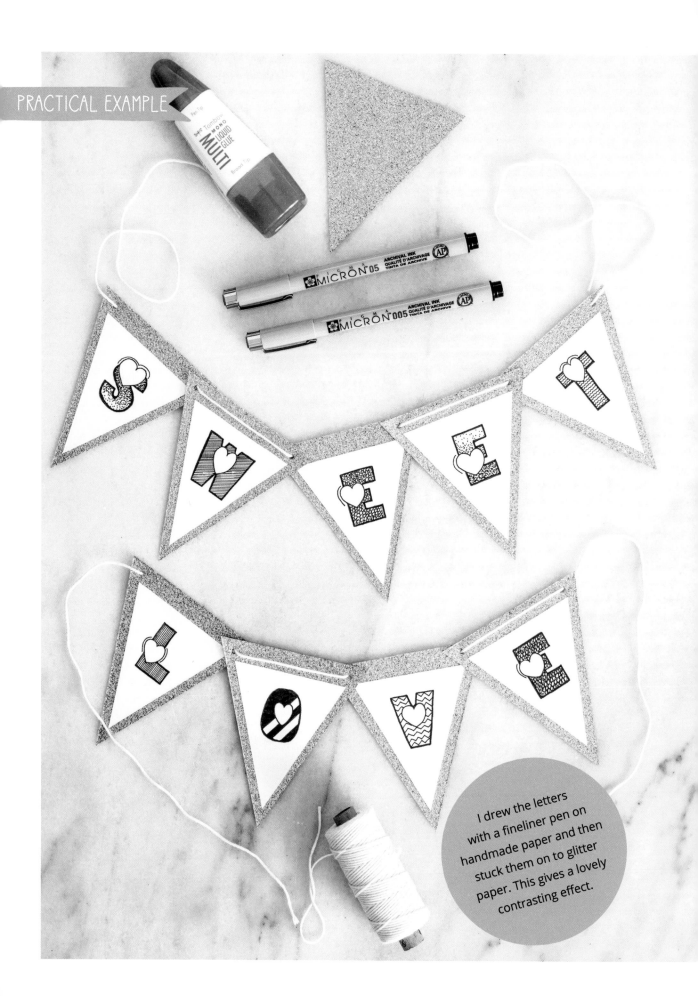

I drew the letters with a fineliner pen on handmade paper and then stuck them on to glitter paper. This gives a lovely contrasting effect.

Bunting can be used for many different purposes - ranging from cake toppers to wall hangings, anything is possible. Not only can you try out different styles of hand lettering, but you can also experiment with various shapes of bunting flags. Here are a few examples:

(1)

Tip: You can, of course, also design other shapes or even cut out individual letters.

Choose a shape[1] and decide how big the individual bunting flags should approximately be. The length of the word and the size of the flags determine the overall length of the chain of bunting. If you only have a limited space available (e.g. on a cake), you need to be careful that the individual flags are not too big. The best thing to do is to make a sketch beforehand.[2] Next, you can think about the design of the letters and the flags.[3] You can either work with coloured card or glitter paper as a background or you can use a dip dye or watercolour approach. You can also make great use all the tips and tricks in this book, of course. For my example, I decided to use glitter paper. ;)

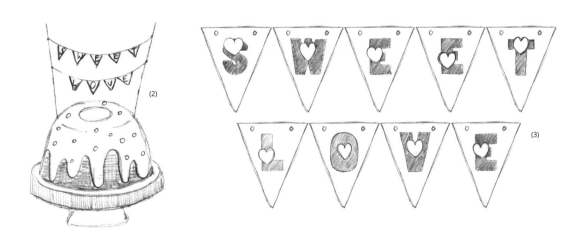

(2)

(3)

⌇ CAKE TOPPERS ⌇

Who doesn't love the pretty cake toppers that you often see on cakes and gateaux? You can even use miniature versions for cupcakes. What may appear simple at first glance, however, is in reality somewhat fiddly, since there are a few things you have to consider when making a cake topper with hand lettering. You also need to be quite patient. In order to make it stable, the written logo must be designed in such a way that the individual parts do not fall off when the cake is cut - this means that all the parts of the writing must be more or less linked together, even the dots on the "i"s, for example. Try to create as many ligatures as possible - the more links you make, the more stable the cake topper will be. You should also avoid making the letters too narrow.

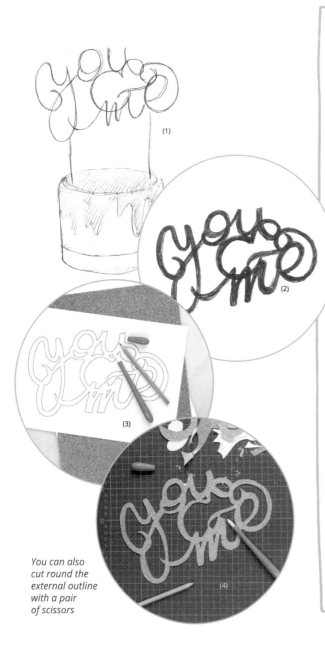

You can also cut round the external outline with a pair of scissors

What you need:

Coloured card or glitter paper, cardboard, tracing paper (white for dark-coloured and black for light-coloured card), a craft knife and cutting mat, adhesive or craft glue, wooden sticks, pencil and paper

What to do:

- Write the desired written logo on a sheet of paper[1] and decide how you can link the letters together.
- At the next stage, you need to flesh your letters out, i.e. to reinforce them.[2]
- When you are happy with your logo, trace the entire text again,[3] in order to produce your final cutting template.
- Stick the card or glitter paper on the cardboard (to make it stiffer).
- Now transfer the template to the cardboard (preferably in reverse on the back of the cardboard, so that you do not see the cutting lines on the front afterwards) and then cut it out carefully.[4]
- Finally, stick the wooden sticks on the back of the finished logo with the craft glue.

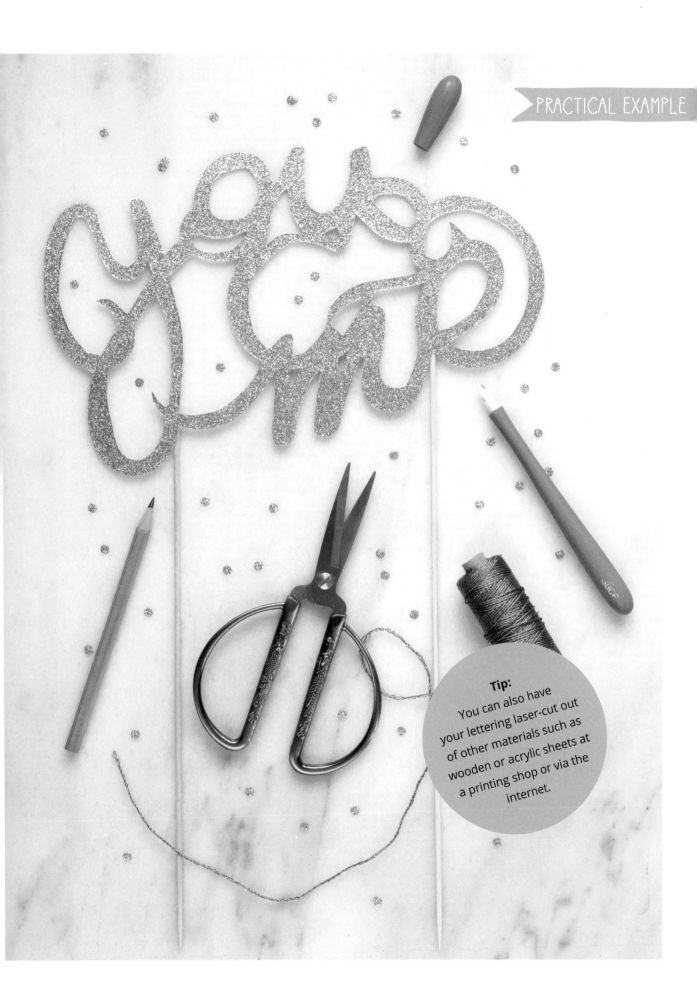

Tip:
You can also have your lettering laser-cut out of other materials such as wooden or acrylic sheets at a printing shop or via the internet.

Danke [1]

Thank you

Danke [2]

Thank you

[2]

Ihr habt dazu beigetragen
dass dieser Tag für uns unvergessen bleiben wird.

You helped to make this day one that we will never forget.

Ihr habt dazu beigetragen
dass dieser Tag für uns unvergessen bl

You helped to make this day one that we will never forget.

TIP:
You can scan the lettering
and then print out the card. [1]
Or you can prepare the card on the
computer with a background and
any other text and then add the
"Thank you" lettering by hand
at the end. [2]

Simply saying "THANK YOU" is something that we should really do more often! In particular, after a wedding, you really want to thank your guests; not only with wedding photos - no, but also with a few personal words, preferably written by hand! As you did for all the other projects, start by making a few sketches and gathering ideas. Do you have a particular format that you would like to use for your 'Thank you' card? Perhaps you already have blank cards that you would like to write on, or even pretty gift tags? What style would you like to use? Here are a few ideas and suggestions of what this could look like:

Thank you

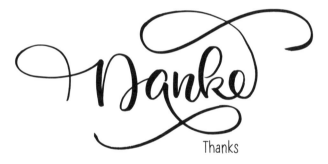

Thank you very much

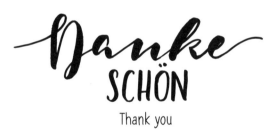

Thank you

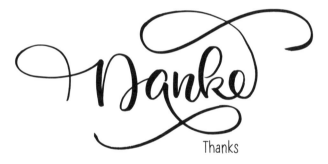

Thanks

THANK YOU very much

Thank you

I like you

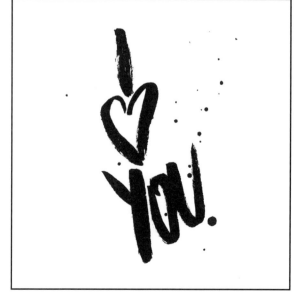

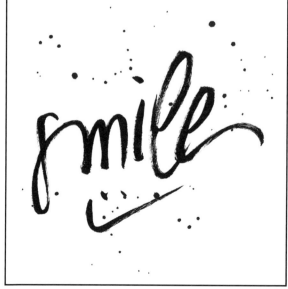

EMOTION CARDS

Now let's be honest: who doesn't enjoy receiving small messages that brighten up your day? Like these little emotion cards – that is what I call them. I just love these ragged letters, which I created in this case by making very fast and jagged strokes with the marker pen. I simply "scribbled around" with my Pentel Brush Pen and, as you can see, I also added a few sprinkles – but take care: please be sure to use a well-protected work surface, otherwise you will have clean up the mess afterwards …

The best way to make the sprinkles of colour is by using a conventional paintbrush and watercolour paints.

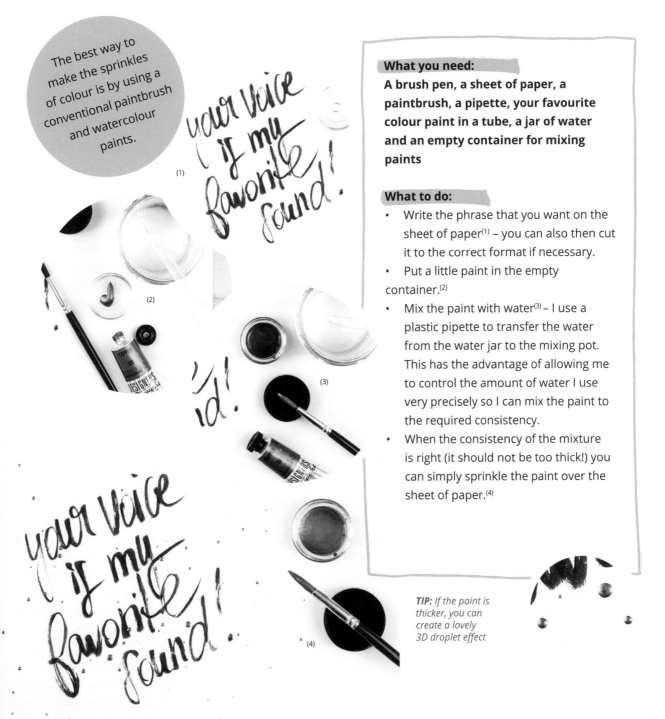

What you need:
A brush pen, a sheet of paper, a paintbrush, a pipette, your favourite colour paint in a tube, a jar of water and an empty container for mixing paints

What to do:
- Write the phrase that you want on the sheet of paper[1] – you can also then cut it to the correct format if necessary.
- Put a little paint in the empty container.[2]
- Mix the paint with water[3] – I use a plastic pipette to transfer the water from the water jar to the mixing pot. This has the advantage of allowing me to control the amount of water I use very precisely so I can mix the paint to the required consistency.
- When the consistency of the mixture is right (it should not be too thick!) you can simply sprinkle the paint over the sheet of paper.[4]

TIP: *If the paint is thicker, you can create a lovely 3D droplet effect*

77

good vibes only

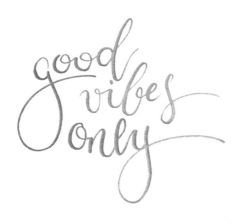

Ich habe einen ganz einfachen Geschmack: Ich bin immer mit dem Besten zufrieden.

OSKAR WILDE

I'm a man of simple tastes. I'm always satisfied with the best.

we love flowers

do what you love and love what you do

Our fingerprints don't fade from the lives we touch.

JUDY BLUME

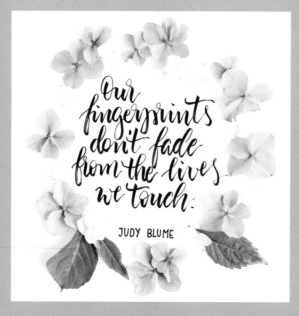

ICH BIN EIN

Optimist

... meistens ...

I AM AN
Optimist
... most of the time ...

Grid for **dip pens**

Grid for **brush pens**